Taking a walk in the woods

Nature-Smart Schools

Rosemary Doug

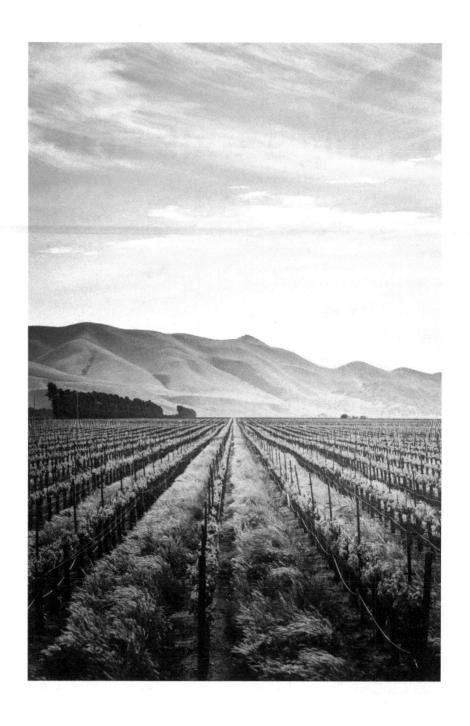

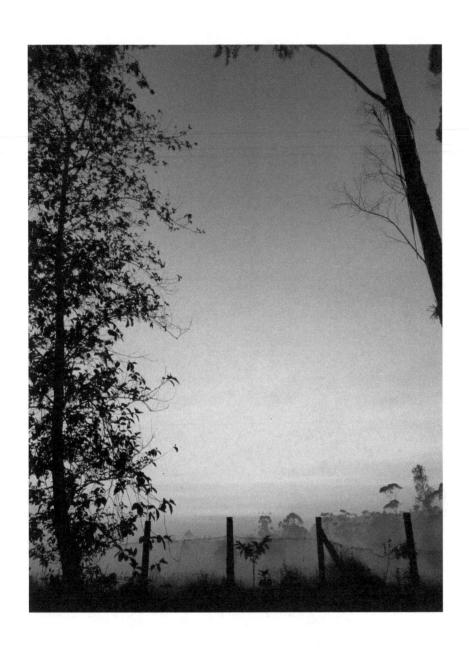

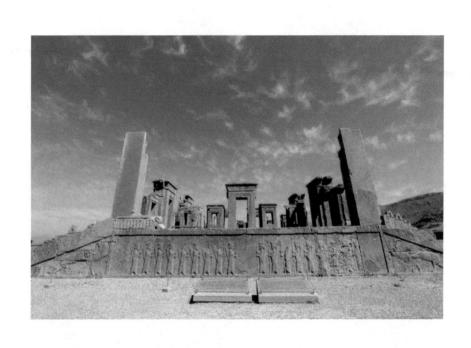

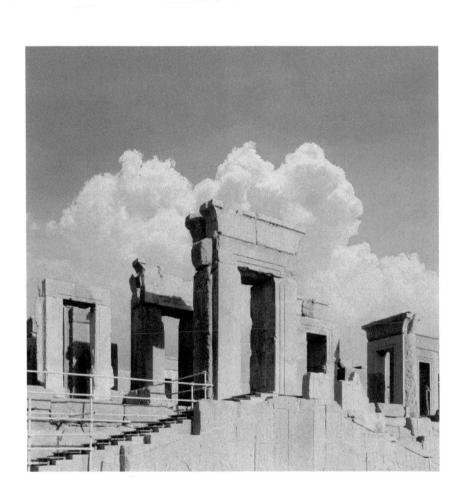

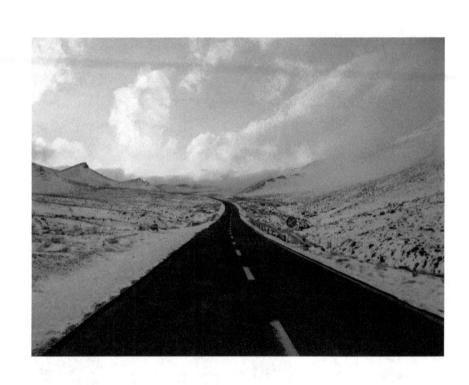

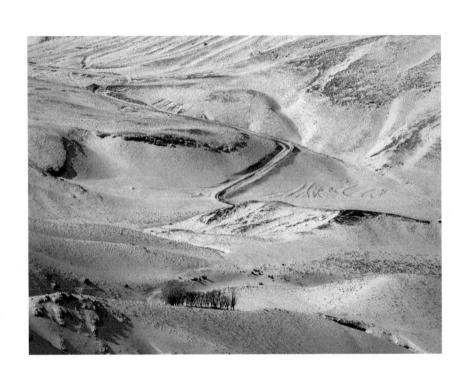

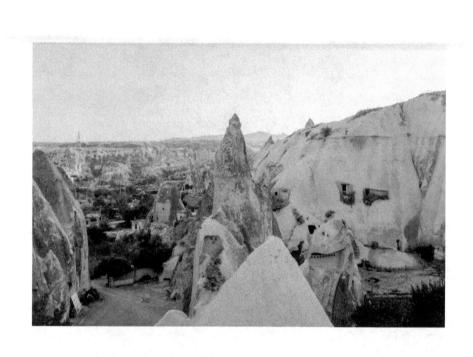

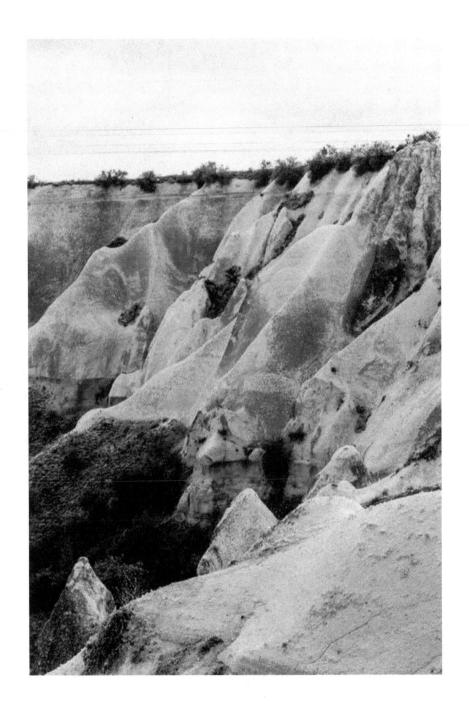

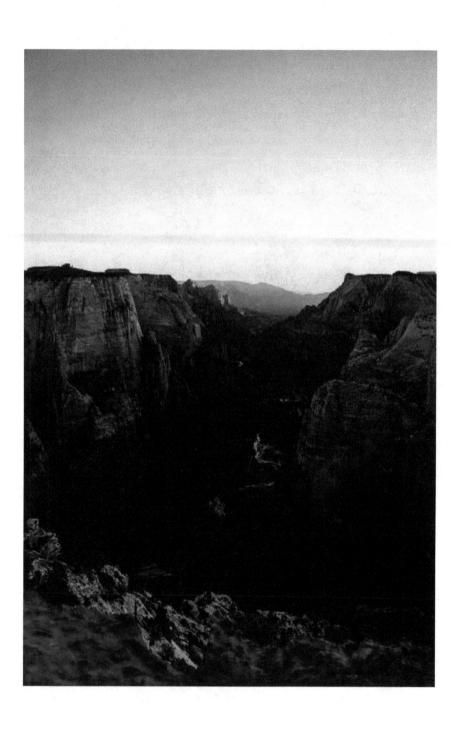

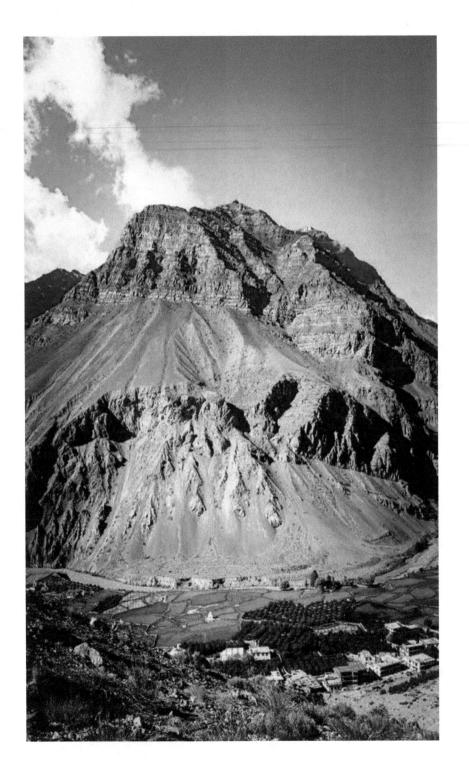

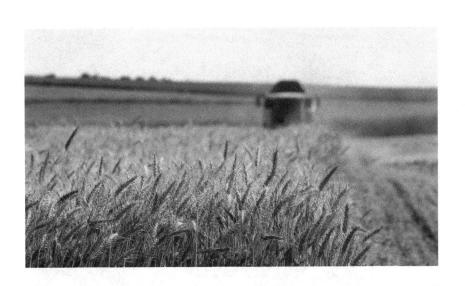

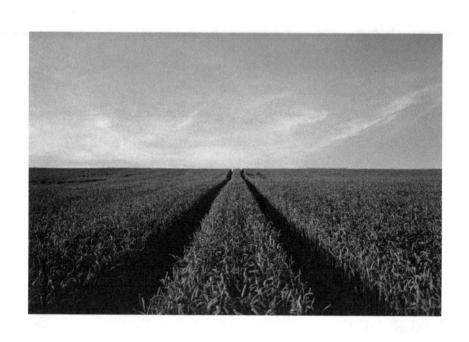

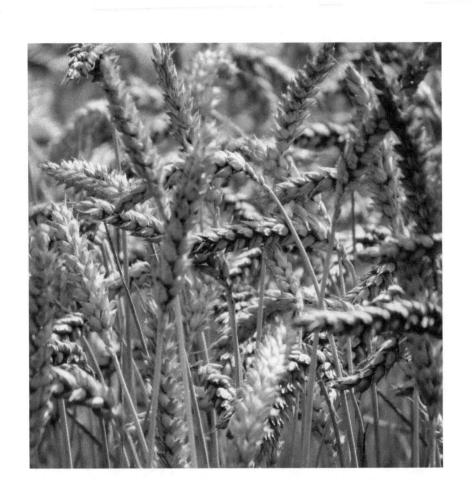

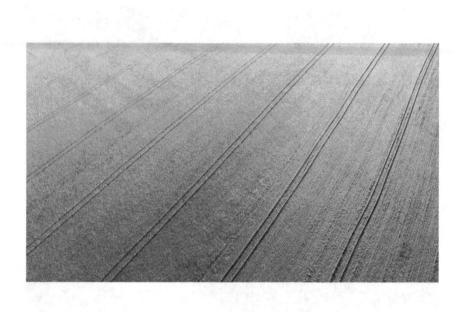

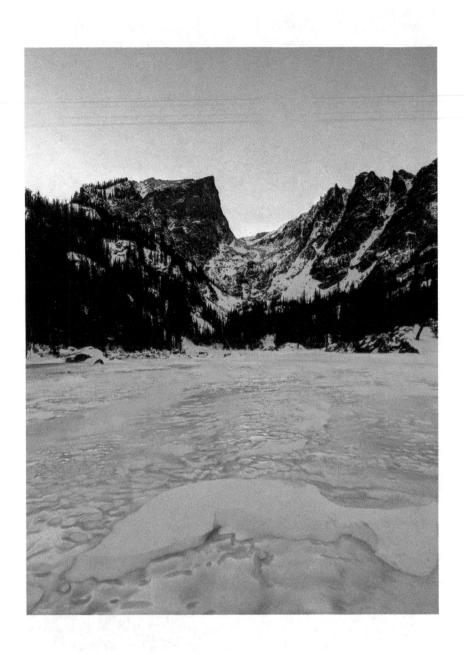

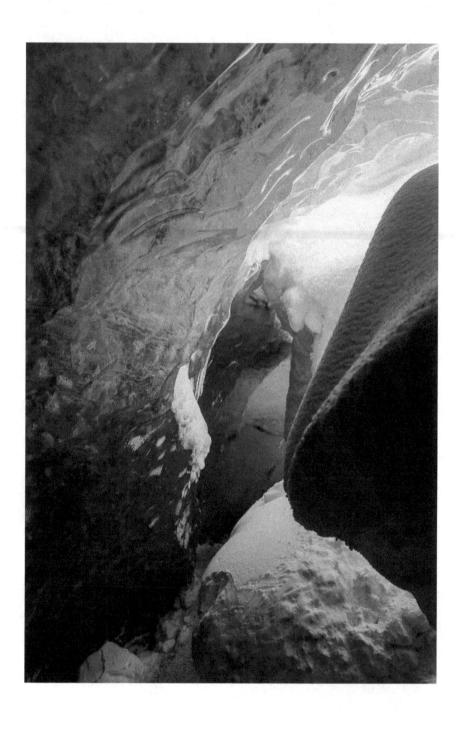

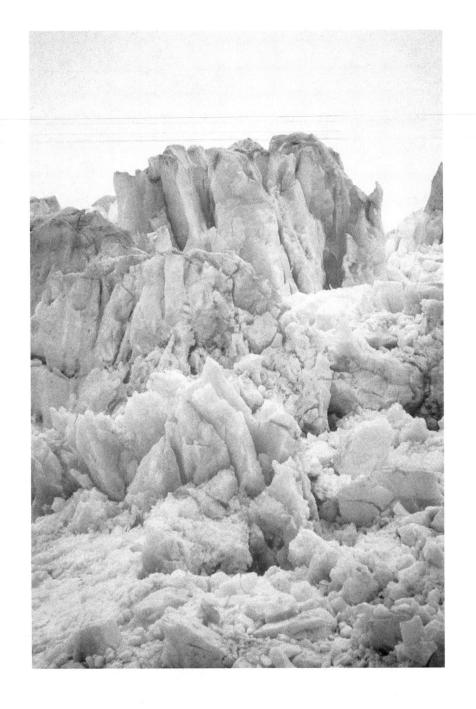

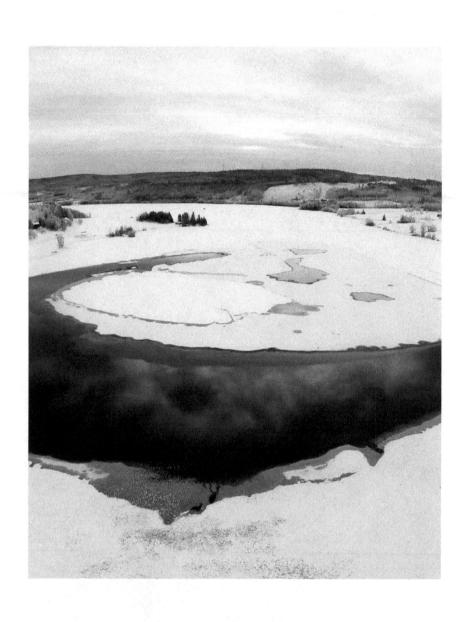

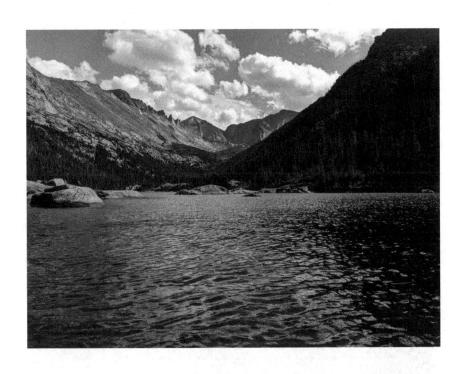

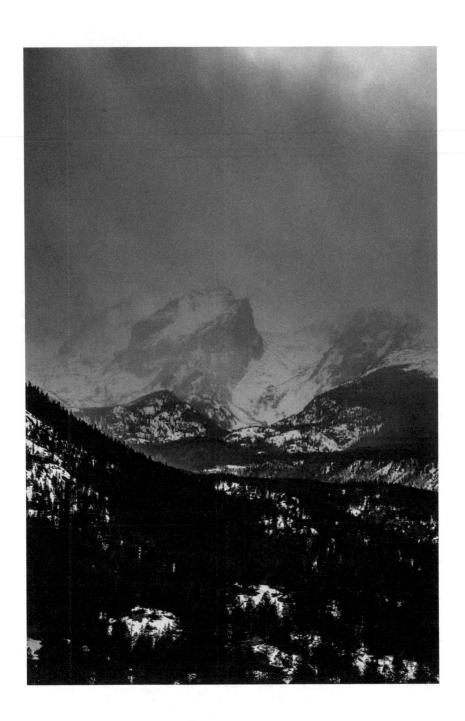

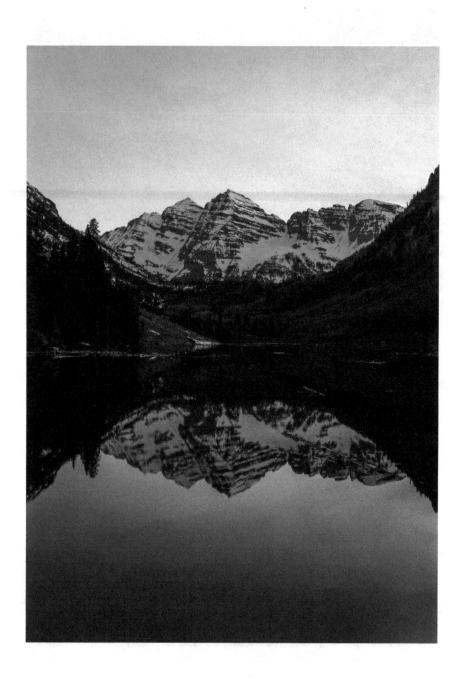

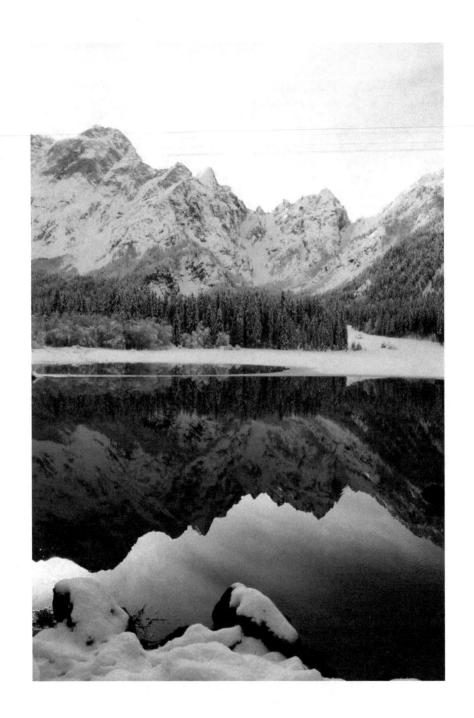

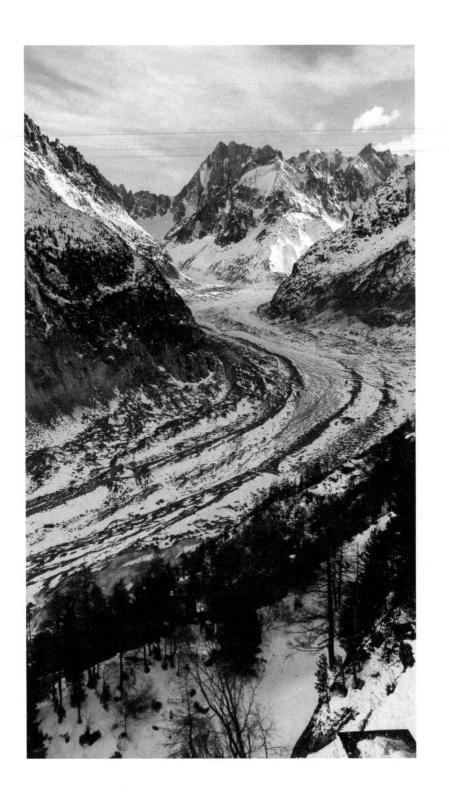

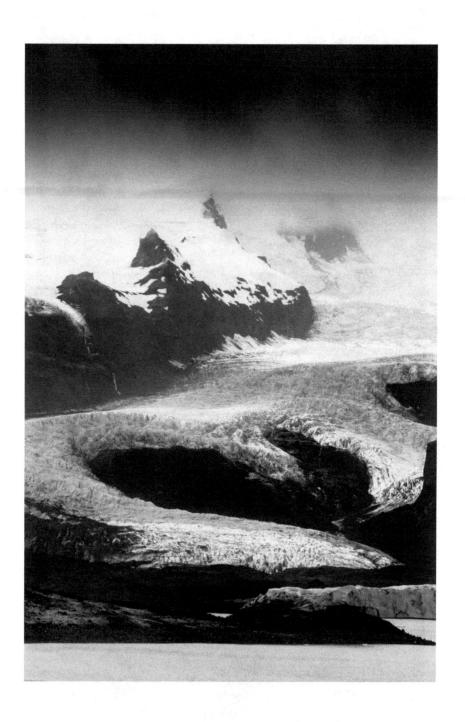

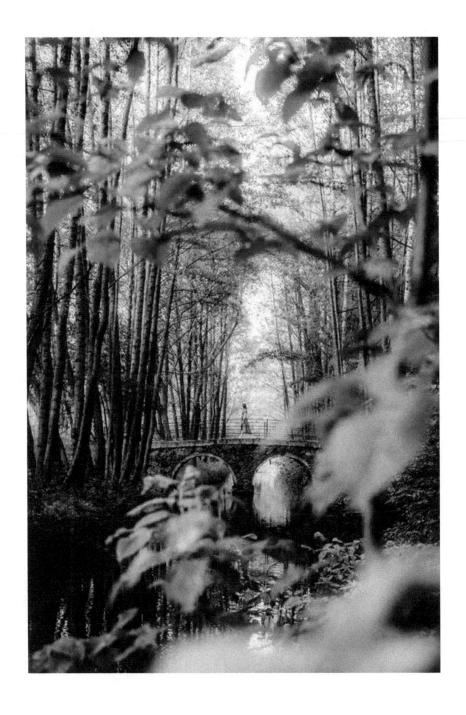

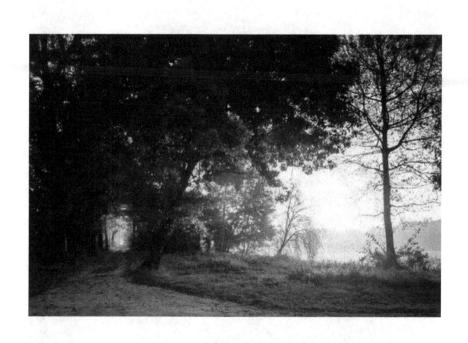

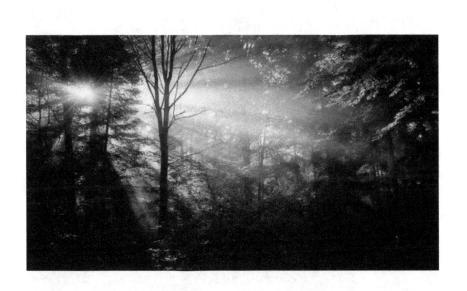

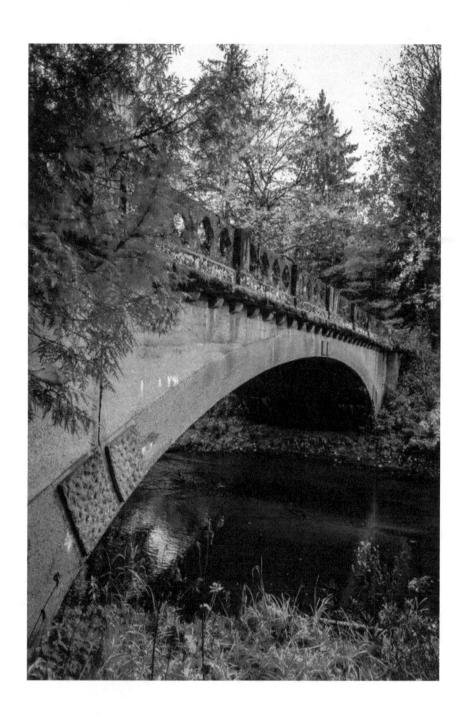

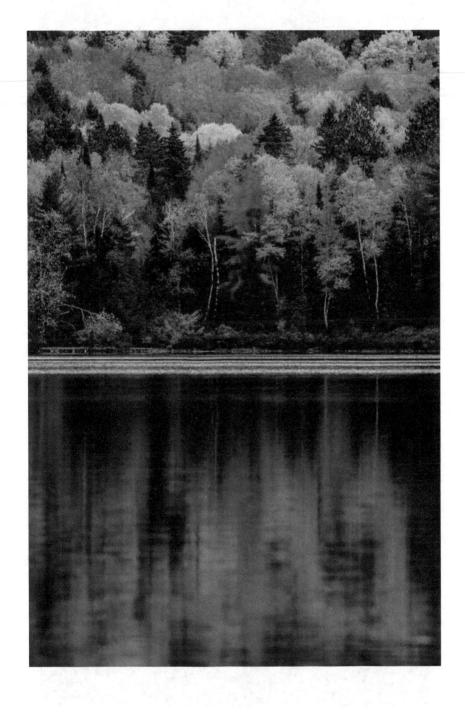

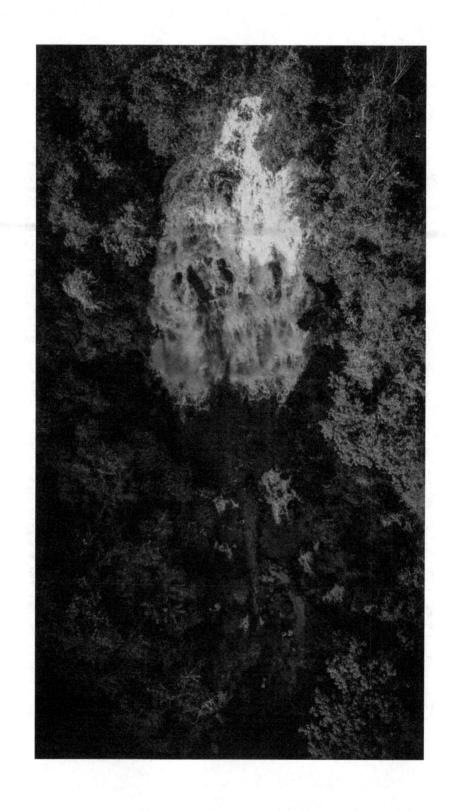

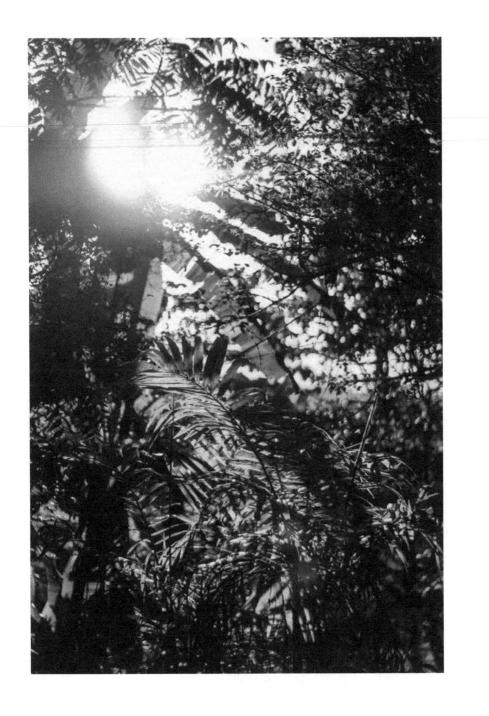

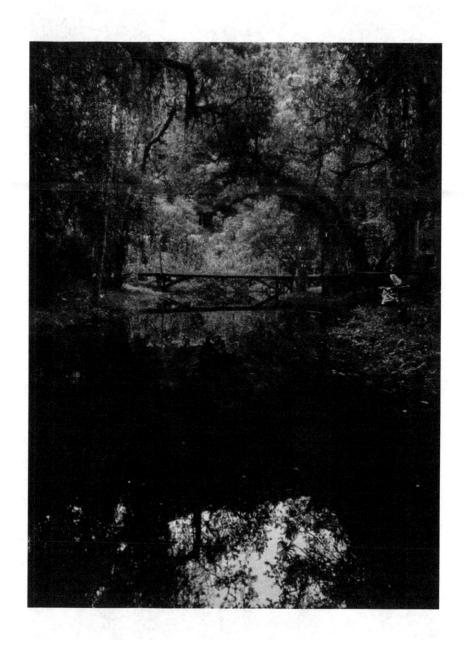

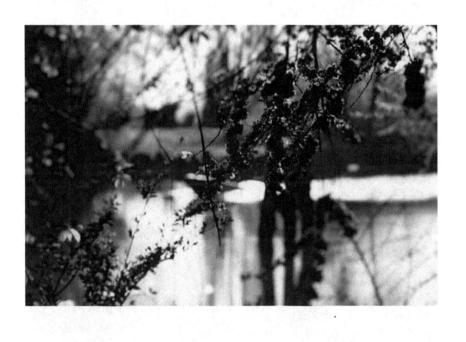

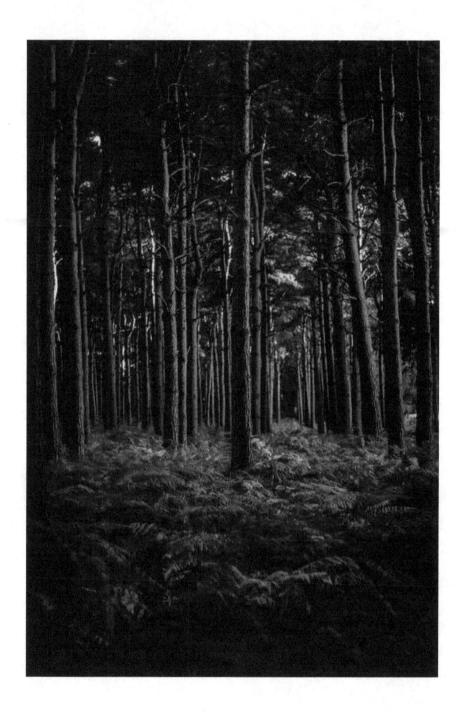

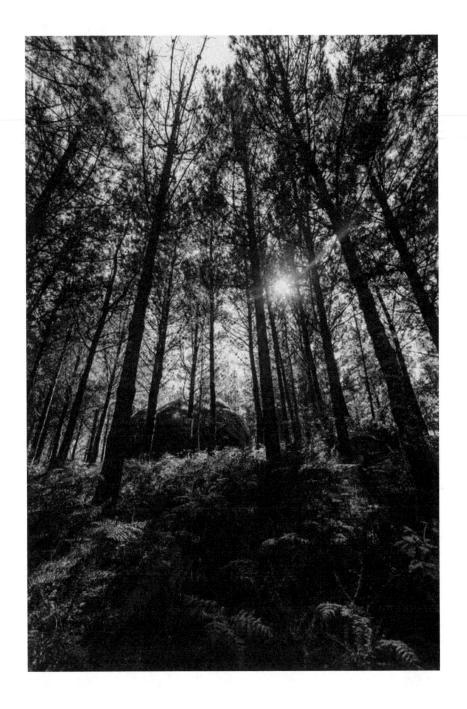

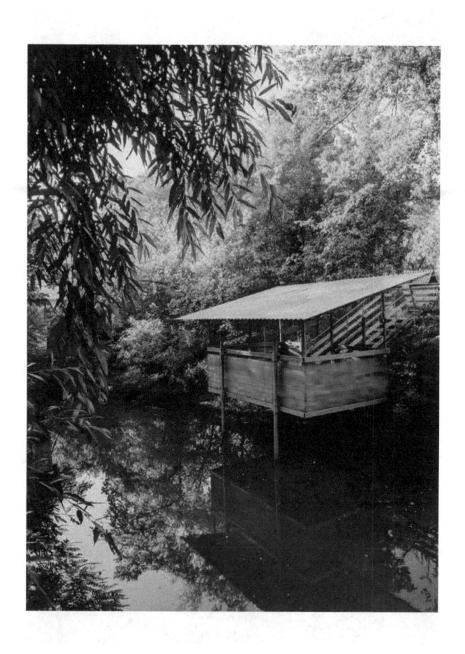

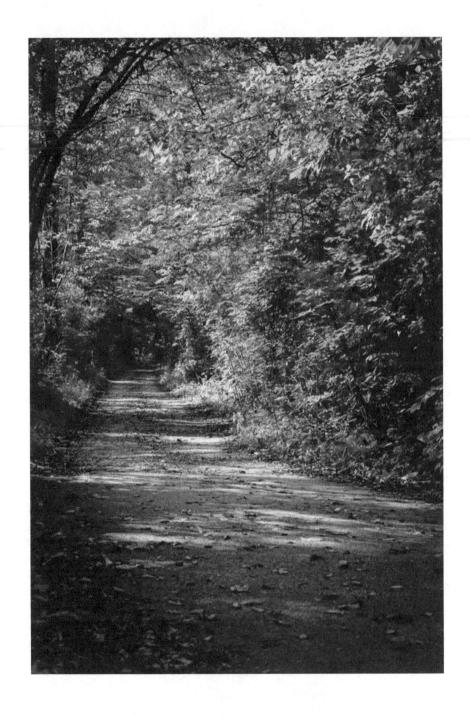

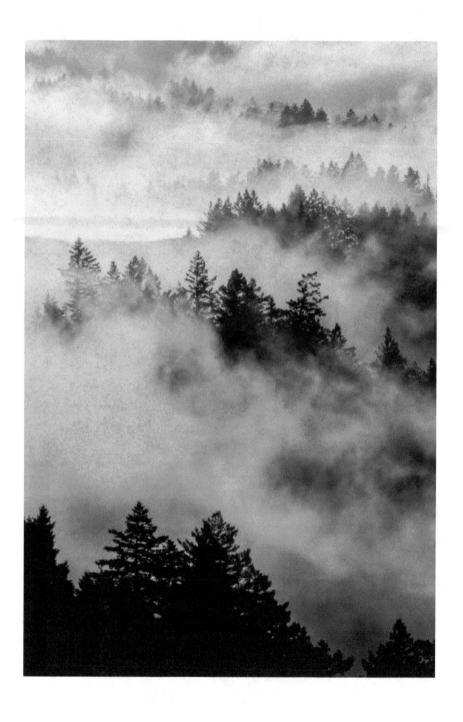

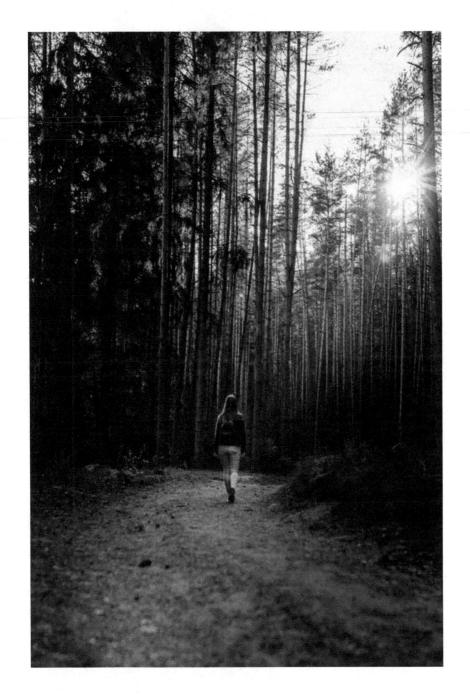

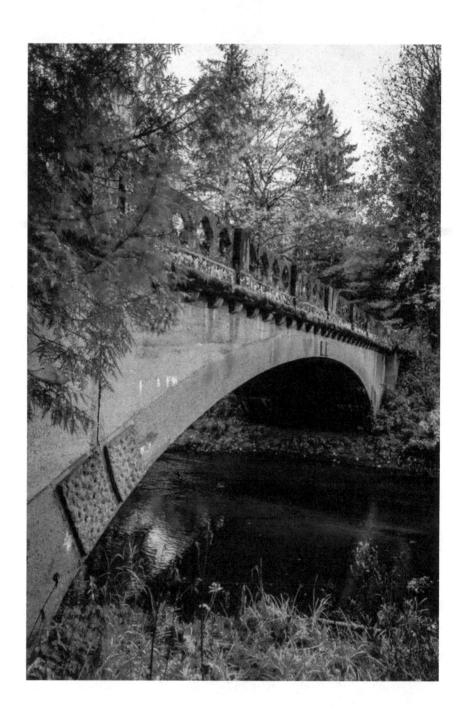

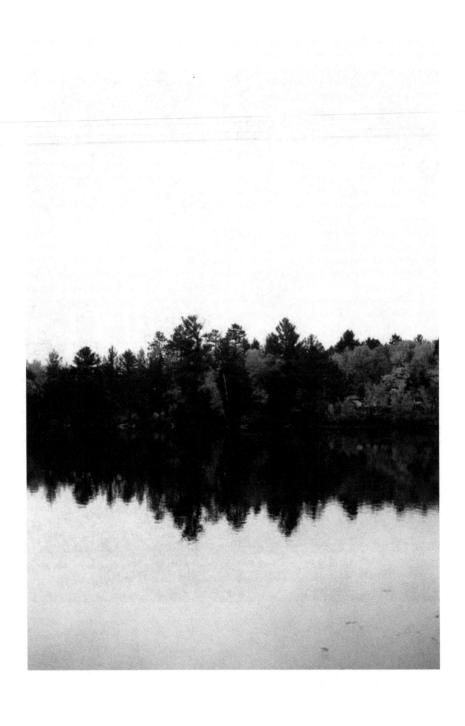

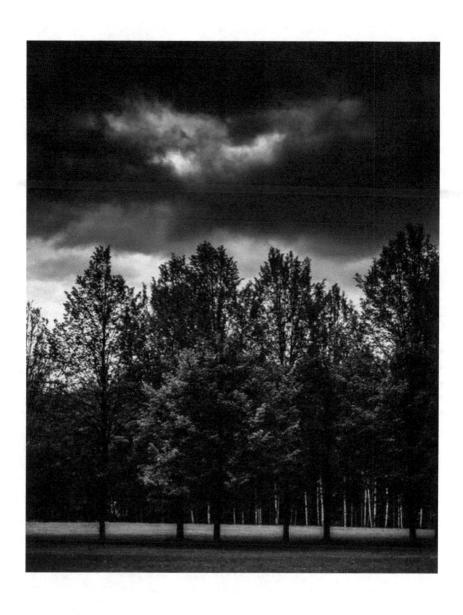

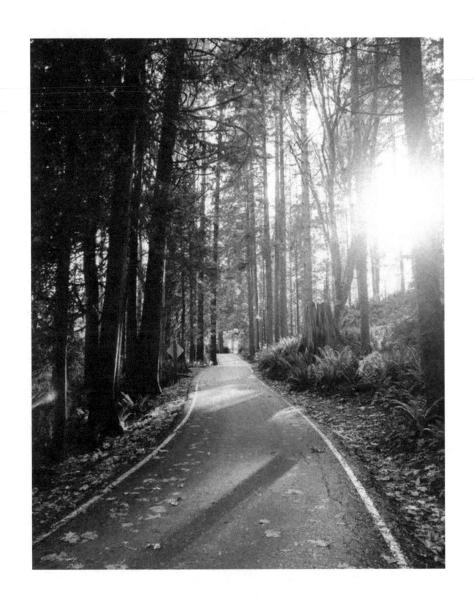

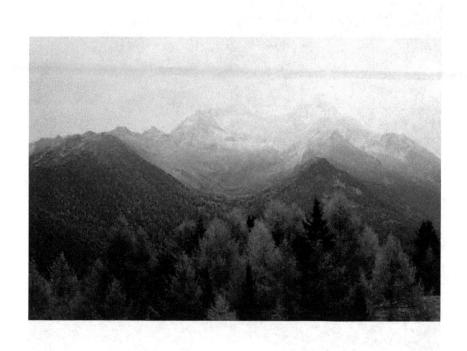

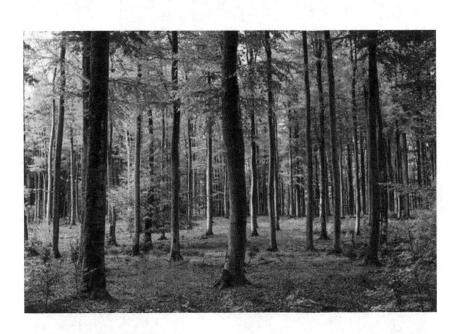

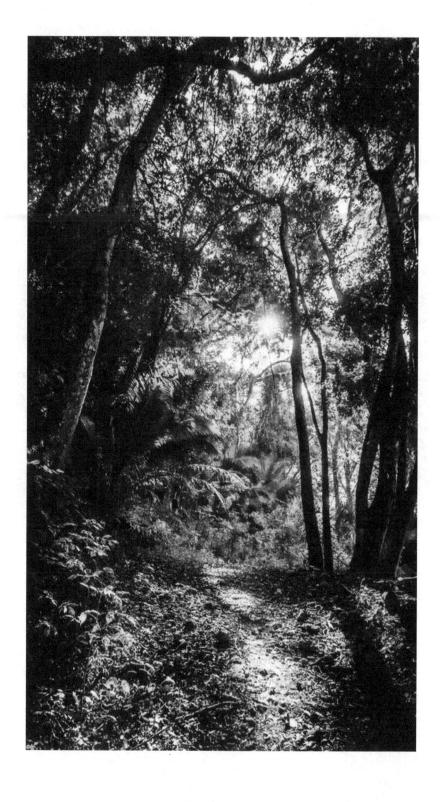

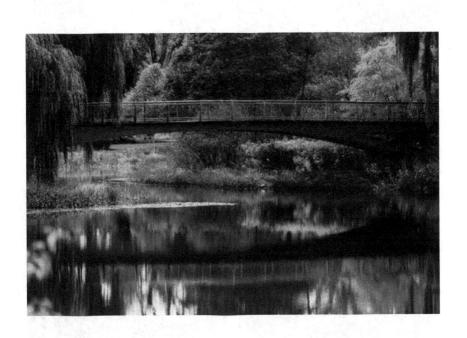

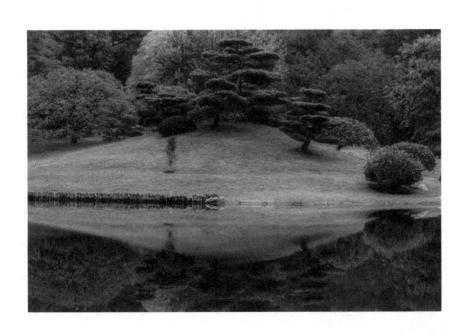

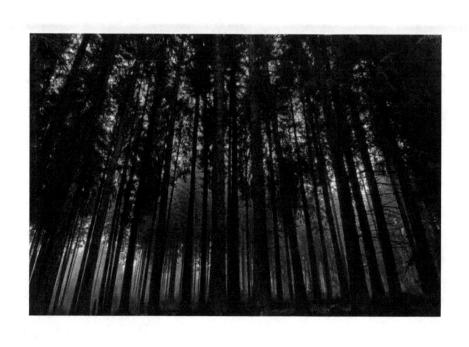

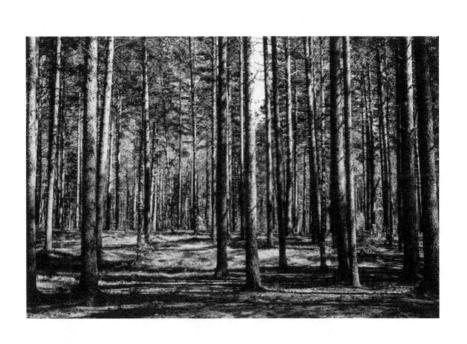

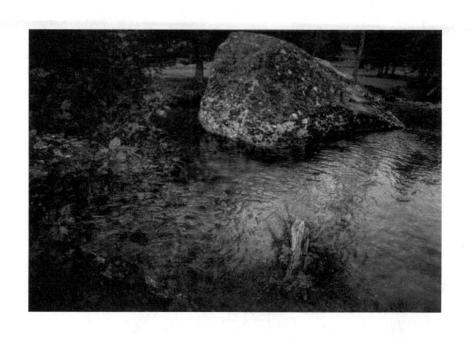

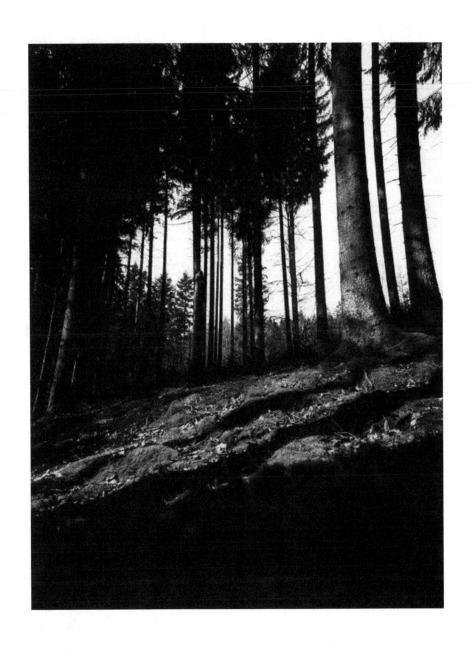

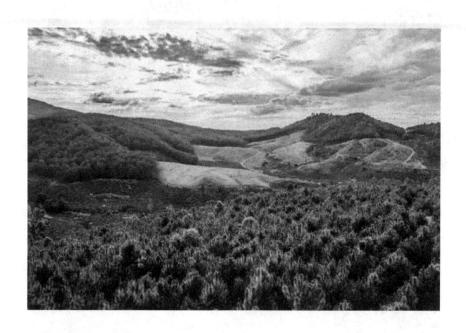

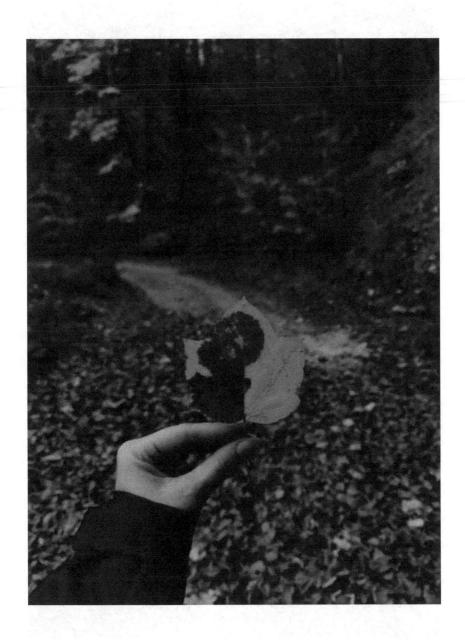

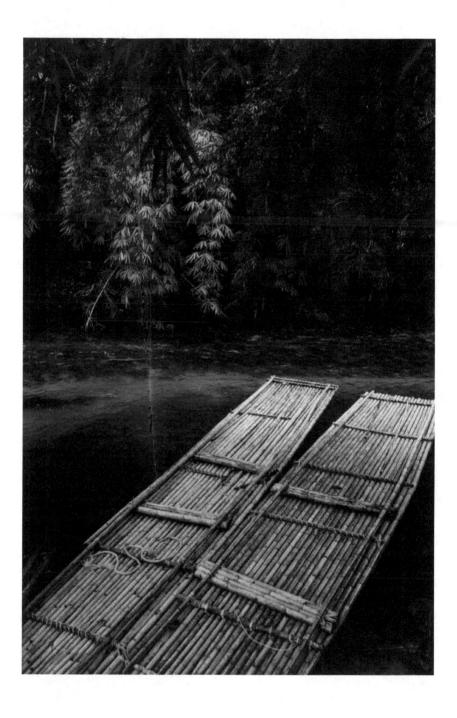

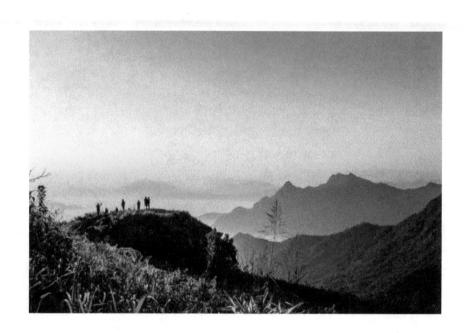

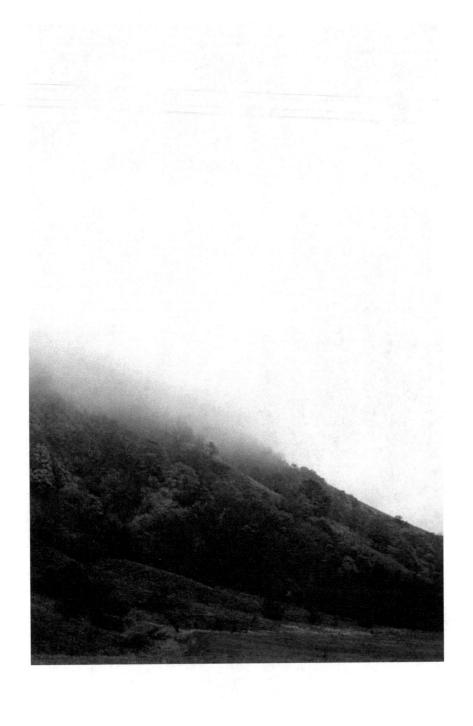

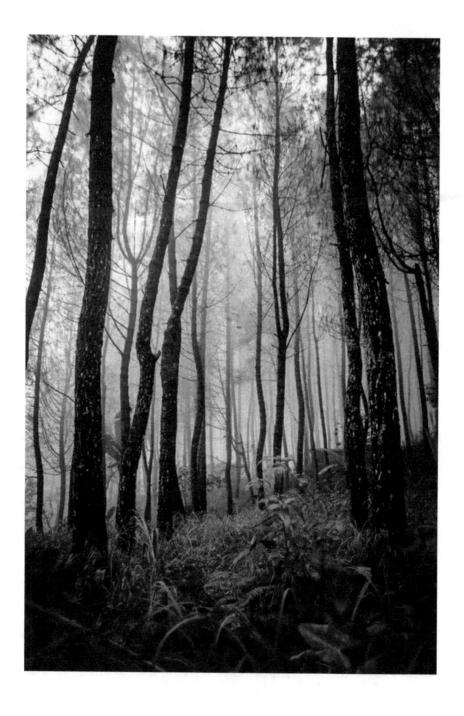

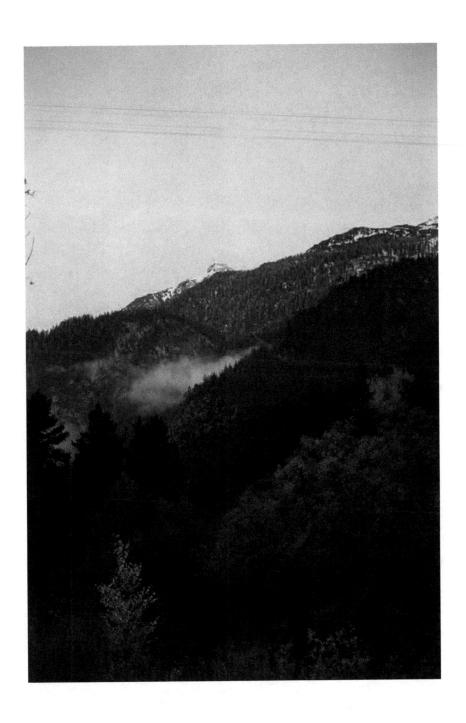

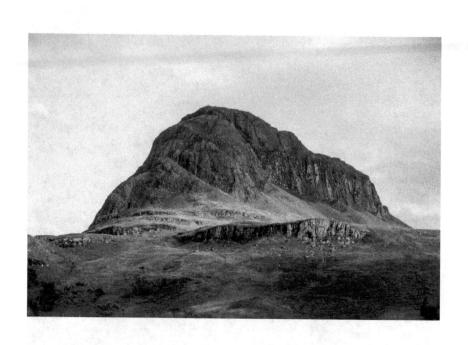

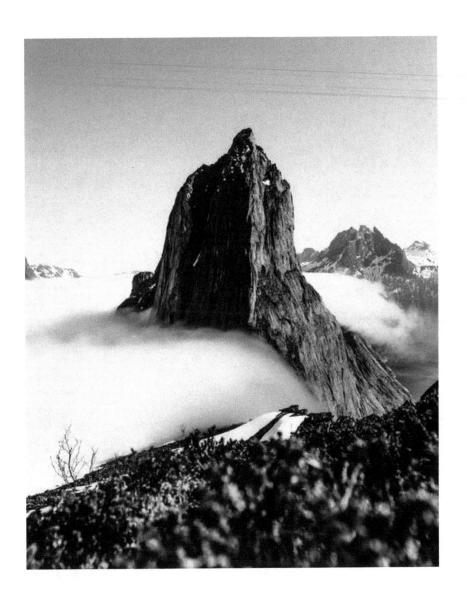

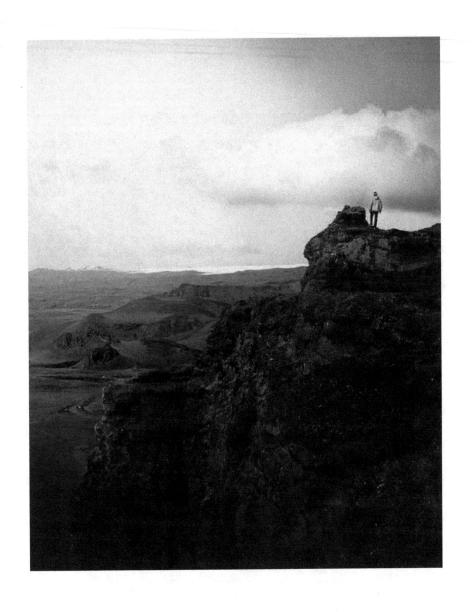

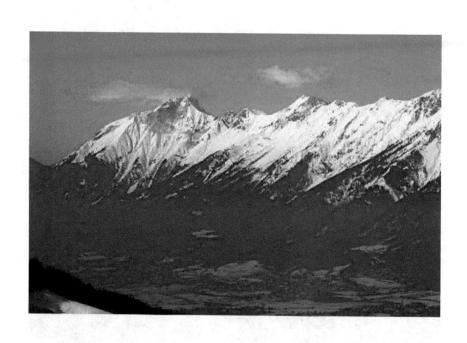

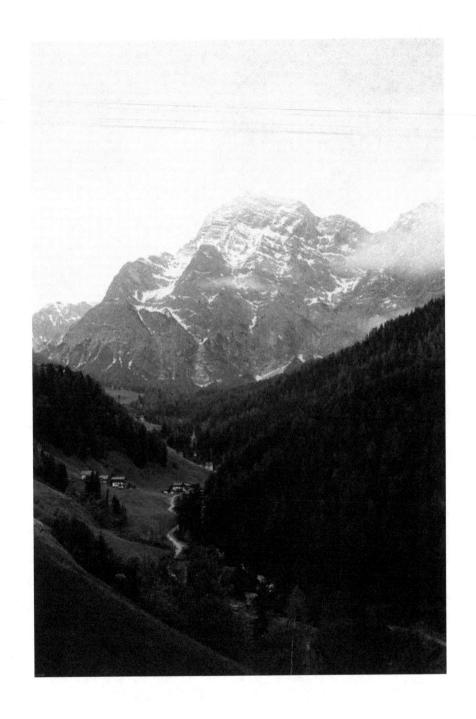

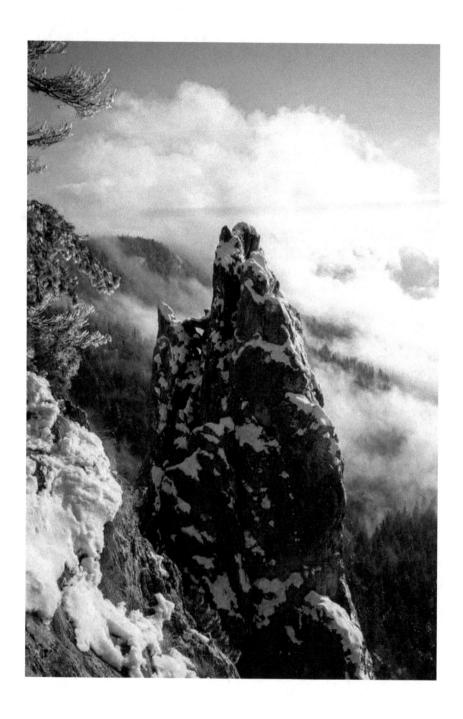

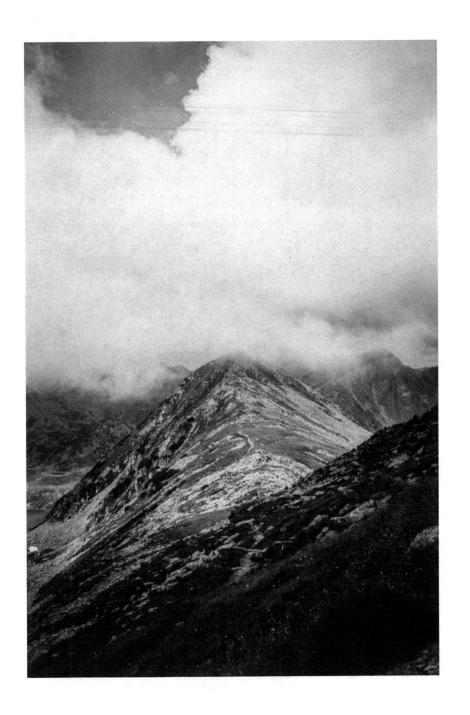

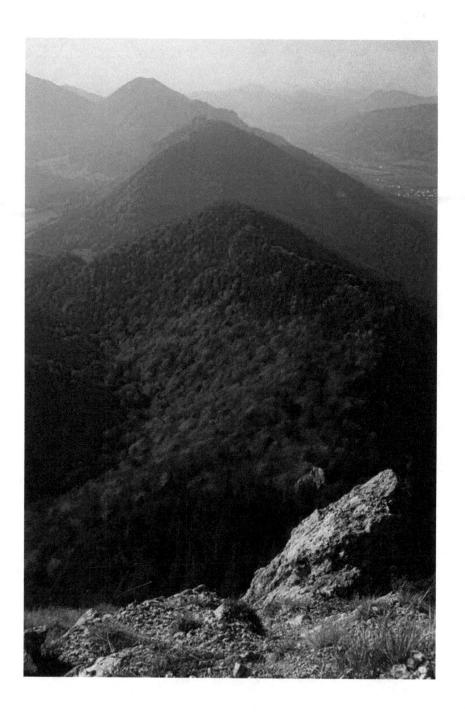

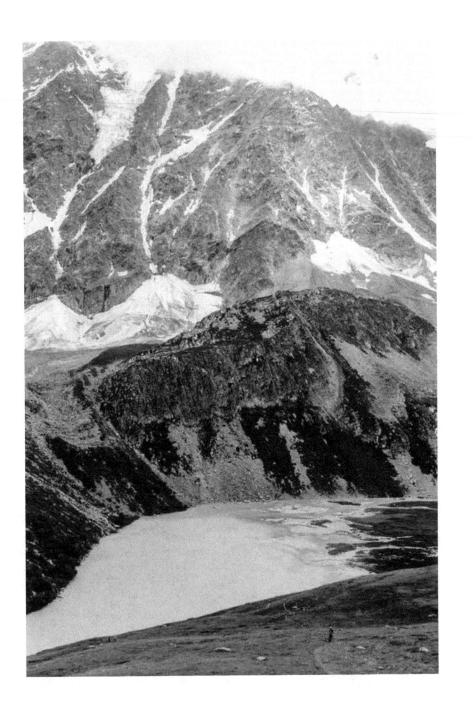

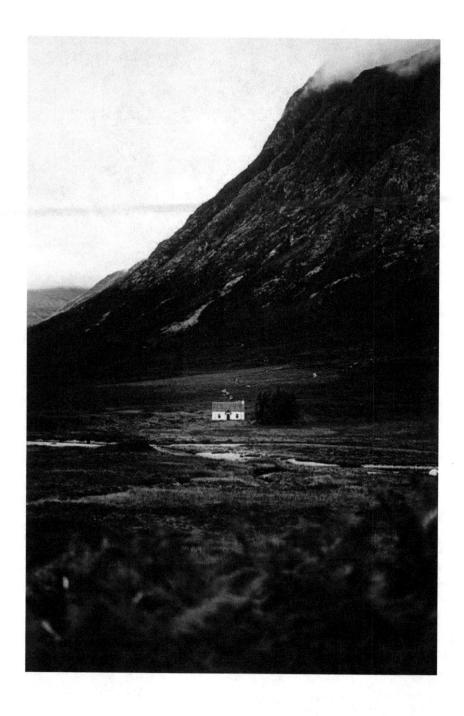

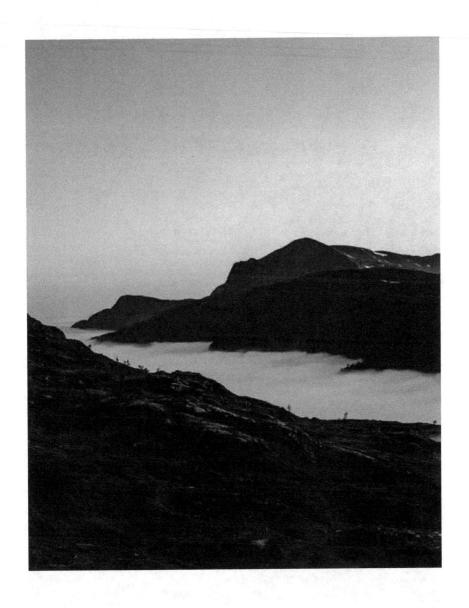

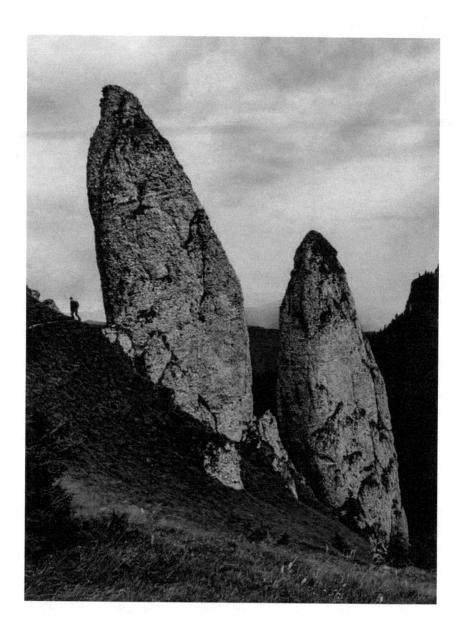

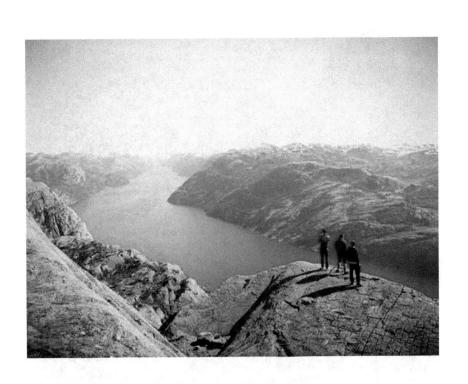

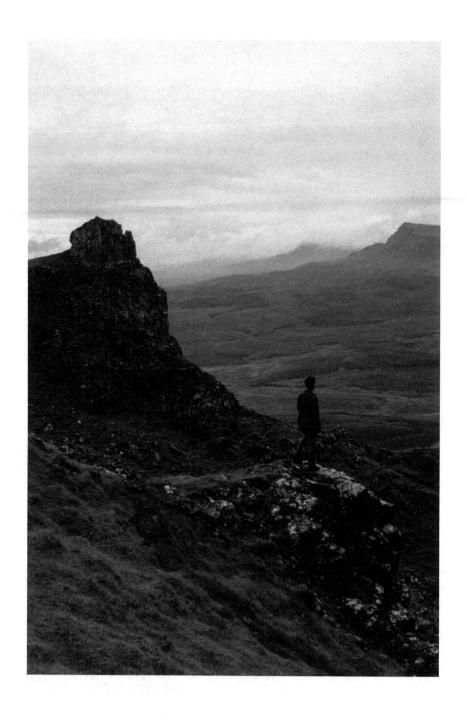

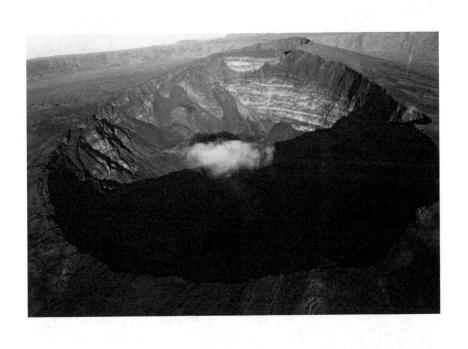

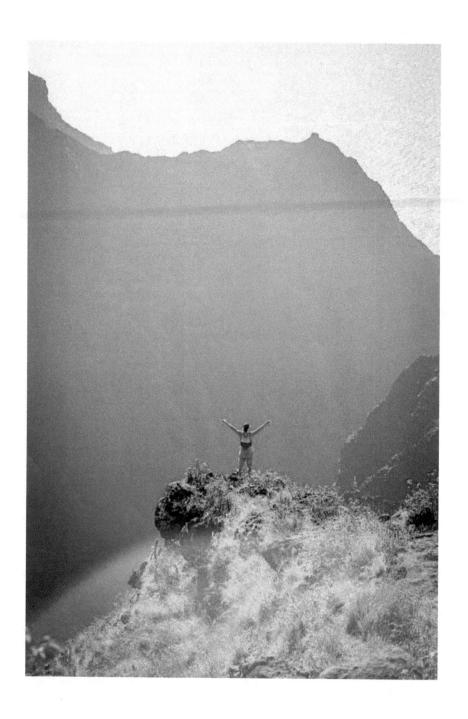

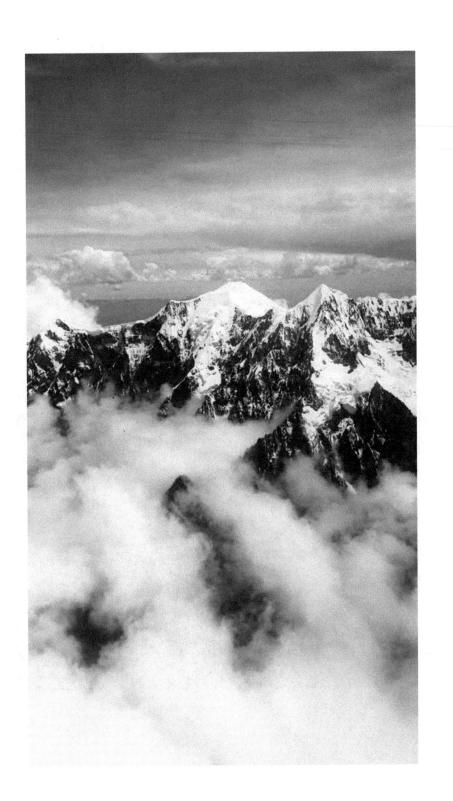

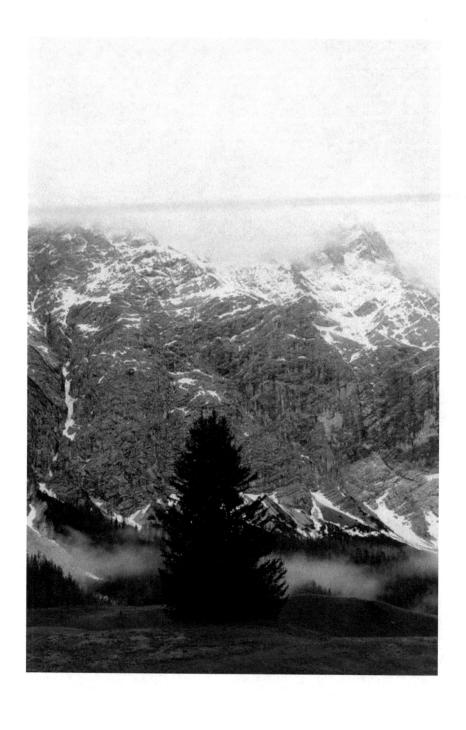

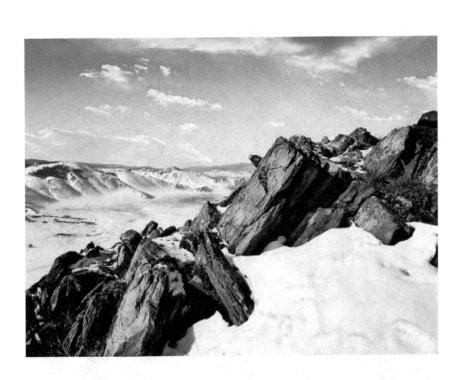

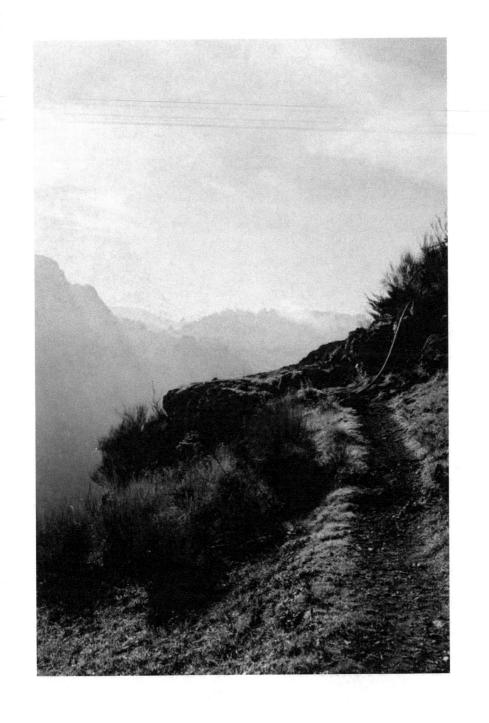

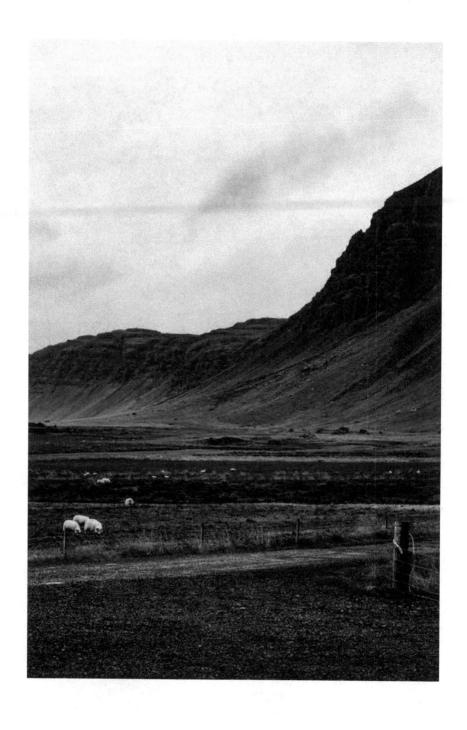

CPSIA information can be obtained at www.ICGtesting.com
Printed in the USA
BVHW050842290621
610725BV00002B/64

9 78 18 03 10 18 28